Praise for Teva Harrison and
Not One of These Poems Is About You

"In her collection *Not One of These Poems Is About You*, Teva Harrison takes you by the collar. *Read me*, she says. *Behold my energy. Feel all of this passion. Remember this love, and keep on loving.* It's a beautiful book. Teva shows her beautiful soul. Step in and feel it."

— Lawrence Hill, award-winning author of
The Illegal and *The Book of Negroes*

"Chiaroscuro is, in art, the treatment of light and shade used to create depth and dimension. Teva's poems have that play of light and shadow. They beam such love and the very whole of life, its essence at the very moment when her own life is receding. She asks us to lean in and listen, and though her voice may be a whisper, it can still shatter glass. Her words hold duality. They are deeply personal, profoundly universal. They are profane and sacred. She is not with us, but she is with us. The poems, each word painstakingly chosen, are polished stones fetched up on the shores of our lives. I am so grateful for this collection: to hear her voice again now, and always."

— Shelagh Rogers, O.C., host and producer of
The Next Chapter, CBC Radio

"*Not One of These Poems Is About You* is a radical act of witness — a testimony to being alive with terminal cancer. Teva Harrison's rawness and vulnerability, her lucid eye and tired body become, here, vital sites of reckoning. This is her offering — to say, *it was like this*, to say, *live*, to say, *remember*. Buy this book. Gift it to others. Love while you can."

— Aislinn Hunter, award-winning
author of *Linger, Still* and *Possible Past*

T0151974

Not One of These Poems Is About You

Also by Teva Harrison

In-Between Days
The Joyful Living Colouring Book

~~Not~~ One of These Poems Is About You

Teva Harrison

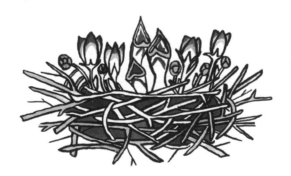

AMBROSIA

Published in Canada in 2020 and the USA in 2020 by House of Anansi Press Inc.
www.houseofanansi.com

House of Anansi Press is committed to protecting our natural environment.
As part of our efforts, the interior of this book is printed on paper that is made from
second-growth forests and is acid-free.

24 23 22 21 20 1 2 3 4 5

Library and Archives Canada Cataloguing in Publication

Title: Not one of these poems is about you / Teva Harrison.
Names: Harrison, Teva, artist.
Identifiers: Canadiana (print) 20190104481 | Canadiana (ebook) 20190105011 |
ISBN 9781487006921 (softcover) | ISBN 9781487006914 (PDF)
Subjects: LCSH: Harrison, Teva—Poetry. | LCSH: Breast—Cancer—Patients—Poetry.
Classification: LCC PS8615.A752 N68 2020 | DDC C811/.6—dc23

Book design: Alysia Shewchuk
Cover and interior illustrations: Teva Harrison

We acknowledge for their financial support of our publishing program the Canada Council
for the Arts, the Ontario Arts Council, and the Government of Canada.

Printed and bound in Canada

Lespwa fe viv = Hope makes life

Contents

~~Not~~ One of These Poems Is About You

Ode to the Pacific Ocean

To stand at the edge of the sea
Waves lapping hungrily

To feel the sand shift beneath my feet
Called out to the wonder and the vast

To feel the salt drying on my ankles
Crusting over my porous skin

I am infinite. I am small. I am at peace.
The swirling, the raging — the disquiet
that usually roils beneath my skin
It is gone, as if it never was

And the waves are crashing
And the waves are lapping
And the waves are creeping in

And my heart is pounding
And my heart is beating
And my heart is open — come in

A Pocketful of Stones

This time
 when she dies,
 a blissful moment when I feel nothing.
Then it rolls up from the pit of my stomach,
a wave of keening whales.

I'm left behind, moving among the living. Alive.

It's raining, but we're still climbing Table Mountain.
I stop at the trailhead — retie my shoes.
"Wait!" I kneel down, palms flat against the ground.

You watch as I fill my pockets with stones.

One for you. One for me. One, each,
for my mother and three sisters.
More, still, for my friends who didn't survive.

My pockets, heavy,
hang low inside my shorts.
I tie the waistband tighter to support their weight.
The ascent is steep. My legs, blooming fields
of bruises from the rocks, yes,
but also from this mountain.

I am careless in my grief.
Slip on gravel, send
it tumbling down the cliff face.
I am careful in my grief.
Keep the precious rocks safe
as I climb.

Tears and rain and salt and sweat.
I'm using too much energy.
I'm inefficient. Tired.
My body weak from treatment,
the periods of indolence that kept me down.

And when we, cut and bruised and caked in salt,
when we summit, I can finally breathe.
But this place doesn't feel sacred.
I can't feel the heartbeat
of the mountain over the din of tourists who
took the gondola up for the view.
We follow the path across
the plateau, away from the people.
The rain discourages casual traffic
and soon we're alone inside a cloud.

In this place, I need to feel the mountain under
my feet. I take off my shoes as you retreat.
Here, at the bottom of Africa
and the top of the world,
I give over to tears.

I kneel down and lay out the stones, one by one:
one for each woman I lost to cancer this summer.
The same cancer I carry under my skin.

I remember you.
I remember you.
I remember you.
I remember you.
I remember you.
I remember you.
I remember you.

And a stone for my mother. Her mother.
All mothers.
And a stone for each of my sisters by blood.
And a stone for my love
who waits while I practice
the only magic I know.
And a stone for myself — lost and found
and lost again. But here,
in this world, hungry to defy.

When I Become You

I'd like to close the distance between us:
where you end, where I begin,

but your skin stops me,
I can't find my way in.

If I could, I'd press every bit of me
against you
until I've slipped inside,
your skin, our tent.

I want to breathe through your mouth.
If I could just slip beneath your skin,
become the better person
you have always been,
I would, in a heartbeat.

Skin to skin. Breath to breath.
I match you.
But it's not enough.
I'm hungry to feel closer.
Closer than sex.
Closer than our past 18 years.
Closer than unborn twins.

I want to breathe myself into you,
curve my body around your heart.
If I could, I know I could keep you safe,
safe from the inevitable end of my body,
my being.

Always, I imagined us growing old
together: shuffling down a sidewalk,
helping each other over mounds of snow,
patches of ice. Falling ill together, lying down
one last time, side by side, to say goodbye
to our life, our long and beautiful life.
Together.

Then, the cancer,
the fucking cancer.

Everything I've pictured is unlikely.
Now, I expect to die first. By decades.
I'll leave you alone with all this *stuff*.
The detritus of a life lived
in a global fervour of collection.
And I can't stop thinking about where this leaves you.
No more big spoon. No more little spoon.
One object left, one object unable to nest.
I will curl myself inside your heart, and try
my hardest to leave you the best of me.

Will it be a balm for you
to be surrounded by my things — our things?
Or will it pang too much to look at them?

You're young.
You have time to heal and fall in love again.
You have time to have the children we couldn't.
With someone new and healthy.

But what of this place where we
nested together? What of the art
we so carefully hung on the walls,
a testament to our love and shared life?
Could this new love (I hate her already!) tolerate
the raw-salt-act of living among my things,
the museum to our marriage?

I count on you to keep our nest feathered.
To surround yourself with our precious, shiny objects.
Please keep me in your heart when I slip away from this body.
When there is no longer a me to love and be loved.
When I let go of everything. Even you.

Shiver Me

Sliver me
shiver me
slice me & dry me:

I'll whisper into the rain.

Deafen/saturate
propel me &
swell me:
pull my words to the street
where they're swallowed
by thirsty drains.

Shiver me
sliver me
slice me a lime

I'm a step-fall-shadow-shimmy.
Tonight,
I'm a ghost
in the rain.

Feathering the Nest

Let's race the tin robots I gave you the first time we celebrated
your birthday together.

Let's find all the toys in the house and build a utopia where robot and plush
can love each other — fiercely, openly. Just as we love.

Let's build a nest and line it with the softest scarves and scraps of fabric,
bubble wrap and twine.

Let's make our home so enticing that you'll stop leaving every day for your job.
We'll lock the door and turn off the lights, curl into each other like kittens,
mewling, nuzzling, purring. We'll drag food back to our nest and feed
each other: soft cheese, crisp crackers. Round fruits and sticks of raw vegetables.
When this runs out, we'll boil potatoes. Make soup. We'll drag cans back
and eat directly from them with our daintiest spoons. When we finish, we'll toss
them into the midden forming on the other side of the living room. We'll suck
on lemondrops as if they were medicine, and they will heal us.

And when our resources are exhausted, we'll fall back into our nest and hold
each other and, as we grow smooth and angular, we'll trace the edges
again and again as they hollow.

When they come for us, find us, we will be bones worried smooth
by a surfeit of love.

Sunburned & Peeling

Unmoored
& keening
in need of your surety,
I'm swinging deeper into myself
to find the pieces of you that might
anchor me.

The polished
tip of your nose
glistening as the rain drips down
from your unprotected head.
Your face is what grounds me here.

You see,
I want to feel it —

the giving rigidity of
drawing-closer-cartilage.

Please?

& when the time comes
to taste
the salty edge —

I will savour the
summer dried on your skin,
sun-cooked & cured for me.

It is the moment
when you reach forward & pull away
simultaneous in your want & need,
in your aversion
to my demand,
that I know (within the now)
this pull this push
this urgency
will outlast the season.

Stasis

This morning is a shivering flight —
a fountain of precipitous silver.

I wrap my edge of warmth closer and part the thick air.

Stepping forward
 incrementally

and again
 stepping forward

disembodied whispers
circle my head like black flies,
nipping at the surface

and underneath:
 the still
 the resonant still,
 it reins me in.

The Things I Do to Keep Cancer on the Down-Low

"You don't look sick."

A so-called compliment, as if looking was as important as being —
or even more so — like, if I can just look well enough, maybe I can *be* healthy —

The work of being a woman, of maintaining baseline aesthetic femininity,
increases to meet every erosive side effect.
>I want to feel pretty.
>I want to feel feminine.
>I want to feel a stranger's eyes linger as I walk by.
>I want just one backward glance.

And even if the cancer didn't factor in, I've entered my forties and my body
is slipping, unruly, curves slouching under gravity's demands.

Cold-capping and micro-blading are amulets that keep the signs of cancer at bay.

I can pretend my body isn't riddled with tumours. I've tricks:
if I wear the water-filled cutlet just right, nestled inside my bra, *just so*,
I can make my silhouette whole again.

"You look great!"

As though the outer manifestation, the hair loss and sallow skin
were the real sickness, and not the spreading, blooming decay under my skin.

No, you wouldn't know by looking.
As if looking *is* knowing: the perfect hair and eyebrows don't stop me
from screaming into my pillow — because the pain and ugliness under my skin
are right here — so close — that we are one, the cancer, me — fused.
No line of demarcation protects me: I live
with a merciless invader who stalks me, endlessly.

This hair that curls ever since the first Taxol —
These eyebrows cut into my skin with tiny knives—ink pressed into wounds
that eventually heal. These breasts, deformed by the ebb and flow
of tumours that swell with cancer and retreat with chemo,
taking my breast with them, in increments —
My toenails curl. I just want to be *me*.

My body holds nothing back.

I'm biting my tongue because this is what I do when you tell me how
nobody would guess that I'm dying.
As if the guessing is what matters, not the dying.

Falling, Without You

Hold on. Hold on.

Hold on to me now.

For I fear I might fly apart.

My nails might lift from my fingers.

My hair might float away,

light as cottonwood,

the laziest snow.

My skin might lift off.

(I hear the sun calling it home.)

My muscles might unravel,

my organs might escape:

I see them lifting, skyward,

so many misshapen balloons.

My bones might rattle free,

chatter and hop

like windup teeth

across the floor.

So please. Hold on.

Hold on to me now.

I can't hold myself together anymore.

Maybe I'm Just Tired

Maybe I'm just tired
but the edges,
my edges,
they're caving in on themselves.

Maybe I've just reached the point of no return,
when delirium becomes mania
and mania becomes disassociation,
but
I need to push back, open-handed —
the so air is thick and close.

Maybe I'm just hyperventilating,
not suffocating.
Maybe it's my expectation that needs re-evaluation,
not my reality.
Maybe I'm too hard on everyone else,
too easy on myself.

But I don't think so.

I think this feeble hope,
this flimsy counteroffer
I've been given in place of my old life
is equivalent to the Emperor's New Clothes.

You know what else I think?

I need to slow everything down.

I want to examine each moment by itself,
and by myself. I'm sick of the charts they map
my body on, my progress on, my decline on.

Maybe I'm just tired,
but disassociation becomes entropy and
entropy becomes a solo lucidity.

 My edges are made of paper
 and weather, nothingness
 and silken threads.

Up to the Edge

Your breath has slowed to an even pace.
You've slipped deeper into sleep, deep enough
that my fidgeting can't touch you.

I'm thankful because I can barely hold still.
I've held still for as long as possible, now.
No more. Ten o'clock, I should be asleep, I know.

I close the computer. Turn off my phone
Work on a crossword for a while.

An hour passes. Squares fill in with more answers.
I'm right on most counts, but I don't know where
the time has gone. I'm wide awake.
I worry the clues, get all the Dad jokes.
That special breed of pun.

Another hour passes — when did I take my medication?
Was it two hours ago? Did I miss my window?
I pop a Benadryl. No shame in needing a little help.

I take all the meds that make me sleepy at bedtime:
an antipsychotic used off-label as an antiemetic,
an anti-anxiety, used for the obvious reasons,
is less effective than it used to be, evidenced
by my overactive brain. Another minimizes neuropathy.

And a blood thinner. That one doesn't make me sleepy.
Just convenient to take with the others.

So I should be very sleepy.
But I'm not.
I take another Lorazepam and hope for the best.

Time passes. I am still awake.
My brain is buzzing like electricity.
I turn on the radio. Set a timer (meds).
I listen to a whole show.

The timer stops.
I get up and take a sleeping pill. Tiny, blue, metallic
on my tongue.
It's got to work.

This is when the diarrhea starts back up.
My body is heavy with sleeping pills and narcotics,
but I know the consequences of not listening to my bowels.
I don't want to feel that shame, so I drag myself back
and forth, back and forth to the bathroom.

Each time, I feel as though I've emptied myself
of everything but skin and bones.
Each time there's more gas and liquid that smells
progressively more metallic, like the taste of
that drug in my mouth.

Time stops holding its shape.
Hours pass at a sprint.
I'm barely surviving, here.

And suddenly, it's been an entire night.

Dawn: my alarm rings. I get up, get dressed.
Go to the coffee shop to order
a pain au chocolat and an espresso
for my love, a latte, not too hot, for myself.
I'm done with burning my tongue.

Back at the house. I wash down a Modafinil
with the coffee, hop in the shower.
This is as awake as I can be on no sleep.
But I'm used to *this*.

I just have to keep from falling asleep
in public again.

I just have to keep from seeing the thin line
that separates me from the immediate, animal-needs
of this body.

Intimacy

Q: What's the most intimate thing?

Sharing a bed?

Using my toothbrush?

Admitting to the lousy performance review
your boss gleefully gave to you while you cried?

Confessing our lies?

Pooping with the door open?

(Never say never.)

Picking up dirty tissues that aren't your own?

Kissing my tumour-riddled breast while telling me I'm beautiful?

A: Hah, you and I both know — all of these things are more intimate
than sex.

Brittle Air/Electricity

Some decisions
make themselves.

Some moments stand on their own,
apart from time and space.

All the clutter/
detritus/debris
barriers/walls
I'm building to protect myself —

All the crackling/electricity
brittle air that/
shatters in my ears/
is suddenly still —
so still/the silence rings/clarity.

All the little/untruths/and
petty misdirections/
fall away and/
some moments/are
pure veracity/
solo verity.

Some moments/
I stand/alone/with my own truths,
acute/supercharged.

Some decisions
Shape/fit our needs.

Some decisions
make/they make/
themselves.

The Points We Turn On

In the tiniest moment,
so small it's almost imperceptible:

> The stoop of your shoulders.
> The fact that I can't find your smile.
> Words tumble out of my mouth, drop
> to the floor and fall short.

In the tiniest of tiny moments,
something immense changes us forever.

Too many moments
when we wonder
what-if or how-so or why-not.

Moments
when we wish
a simple apology or an omitted word
could make the difference
between what is and what we wish could be true.

These are moments that change, only, in how
we remember them.

We twist our memories to suit our needs.

We're humans with complex feelings,
complex arrangements of love and need,
hope and disappointment,
fear and wonder.

And when we open ourselves, in optimistic humility,
when we pour ourselves into an idea
and count on that idea for sustenance,
and that idea crumbles beneath/above/around us,
when we hear that crack of giving in, of giving up.

These are moments we can't turn back.

Voice

Granny's voice cracked. She hated that it made her sound old.
She was a very young grandmother — only in her forties.

But her voice was shrill. When they removed her cancerous thyroid, they
damaged her larynx, and changed her voice forever.

For me, it was her voice, the only voice I ever knew from her.

And her voice crackled with energy. It demanded attention
even if it was flat and without affect.

Even with such a diminished instrument, Granny held
her own space in the world.
That, and a little extra for all of us children.

I can still hear it in my head. Memory is helped along by
the poke and prod of my own vocal paralysis.

I open my mouth and a shrill simulacrum of my voice
tumbles out. And it grates like hers.

I can't predict it. I can't control its timbre like I could,
just three months ago.

Has it only been three months of this?
Three months of opening my mouth,
and wondering if anyone will be able to hear me?

My damage isn't even proximal. Cancer ate away at a nerve in
my chest and in my neck and my body stopped taking my orders.

It started small.
A pupil that wouldn't dilate.
A drooping eyelid.
A section of my face that didn't sweat.

Small things. You'd barely notice.

Then, one day, my voice cut out. At first,
it came and went, like static on the airwaves.

One day, it went and stayed away.
Days passed, and longer nights.

A month of silence broken by a shrill squawk.
I opened my mouth and baby birds tumbled out,
glistening feathers, wet with the viscera
of my stomach, slippery with bile.

Their erratic chatter added up to nothing.

I shut my mouth up, boxed it shut,
preferring silence to their company.

Self-deception

She wanted to be the kind of person who could carry the secret
to the grave.

He wanted to be the kind of person who didn't let it change anything.

They were not those kinds of people.

Edges

Flying out of my seams
I come unravelled

What is the stuff
of human binding?

The stuff keeping the relationships
of our thoughts
our petty revelations
orderly and clean?

I wear the edges of everything
bend and scratch and tear
I'm hard on the world
&
harder on
myself.

Closer

She pulls him close, pressing her hungry skin against his.

"I want to be you, to be in you, to melt away my edges and yours."

Sliding against him with the fluidity of an otter,
she fed her skin on the warmth of his. Slipping her arms
down to his, tracing the softest bits more slowly than the rest,
the inside of his elbow, the backs of his knees.

He squirms, trying to suppress the tickle, but it grows like a sneeze.
All the ways that he might burst, or push her away.
It was all he could do to suppress the childish instinct
to punch her for tickling him — but he wants everything she does.
He wants to melt into her until they are one. Leave the duality behind.
He wants to feel every inch of his body against hers, even once,
to have that memory to hoard, to curl up in on a lonely day.

She's gathering momentum. Frenzied with heat.

"Slow down." He wants this moment to last forever, this *before*. "Please."

She opens her hands, freeing the tight clutch she had on his.
Her fingers are sweaty. Blowing on her palms to dry them becomes
blowing, gently, on his clavicle. And then the tracing begins again,
a tender exploration of his skin, the one she wants to be within.
The one she wants to climb into. The one she wants to be.

(s)pacing

Focus inward
& you find that these
words are only
the perimeter.

They barely contain
my surging,
my urgent impulses.

These words
that govern action
through their definition.

I am
circling their perimeter
I am growling inactivity.

I am
a step away from
unshuttered light,
fierce lucidity.

Shallow Breathing

In bulbous orbs and creeping tendrils, my cancer bloomed. My cancer
grew faster, *faster*, and my liver could not stretch to accommodate.

I knew before the scans.

The suburbia of my liver's world pressed against my ribcage.
I couldn't twist, carry a purse, sleep on my side.

The hasty expansion of my liver pressed against my stomach. If I ate, it
pushed back, sending me, running, to vomit in the bathroom — to heave,
concave, above the cold ceramic bowl.

And my breathing, so shallow. On a scan, I saw my lung, collapsed,
pressed flat by a grey lake of fluid — So, this is what they mean
when they say *water on the lungs*.

Shallow breathing, enough to carry on, but slowly.
The colony of tumours inside me, asking for more space.
They'd like to spread to fill to prod to push the skin
that contains me. And then burst forth, destroying us both.

My oncologist looks at my liver enzymes, spiking off the charts,
and makes a crack about how much I must have been drinking
on vacation. *I wish, and if you only knew how much I want—*

I'm worried, he says, and sends me for a series of scans.

My liver continues its sprawl, a manta ray spreading its wings
inside my abdomen.

The flesh-sac around my left lung grows tumours and the tumours draw
liquid, filling the flesh-sac up and crushing my left lung.

And, finally, I am rushed into the surgical theatre,
where a surgeon makes a tiny incision between my ribs,
weaving a tube toward the lake in my belly. I watch
as they suction and drain yellowish fluid into two-litre jars.

Not even half-finished the procedure, and I feel relief.
Like I might be able to breathe again.

Sustenance Song

I eat more when I'm with people.

These days, I'm not with people much.

So how long, how long, until I disappear?

Closer and Closer

My dreams,
they're closing in on me.

Circling vulture-thoughts,

I close ranks,
circle the wagons,
try to make some sort of phalanx
to stave off their steady onslaught.

They're relentless.

My dreams,
whispers into screams.

The fatigue is wearing.
I can barely keep my eyes open,
then
I can barely keep my eyes shut.

A constant rally—
back
 and
 forth.

My dreams,
they're closing in on me.

Dream, Dreamer

Bad sleep again.
Dreams so powerful that I bolt
upright in bed,
but they dissipate immediately.
Why can't they linger?
A tiny gift of the absurd
edifying to make
the uneven rest bearable,
desirable, even.
Or are the dreams so awful
that my subconscious
is doing me a favour by
rendering them null?

Still, like most things,
I'd rather know.

For too long, now, medication
has changed the architecture of my sleep.
Dreams moved out of order.
Instead of burbling to the surface
at the end, they play out in the dark.
These new meds, though,
they've restored my body's
natural sleep cycle.
Every night, I twitch

awake
from a story or a memory.
I've lost the ability
to differentiate.
Sure that it
will return
if I just let it,
I stare into the receding
forms as they fade,
like fog burning off in bright sun.

The adventures I had.
The fantastic lands
that I flew to, sweeping
over forested mountains.
I'd give anything to
remember my dreams
like I used to in my childhood.

If only, I could still tell my mom
the whole story over breakfast,
maybe bore her to death
with every detail.

These new drugs make me sleep.
Deeply, and for a very long time.
Remembering my dreams
would lengthen my experience
of the day,

filling half with adventure
or absurdity.
They might balance
the time I spend
in the hospital or in pain,
or both.
Of course, the dreams could
simply mirror my days,
but I have more faith
in their creativity.
I'm certain
that I can slough off my body's
limitations in sleep.
That I can fly and find
my way back to the boundlessness
of my childhood.

The first step is remembering my dreams.
And the instant I open
my eyes, they're gone.
As if they never existed
to begin with.
As if those hours of the day
never happened at all.

Wrecking Ball

I am afraid that I have torn down
all that I have built
 systematically.

My selfishness knows no bounds
(not really).

There are grounds to dismiss me.

Let's not get into it now.

Your voice resounds in my head:
It's telling me not to go there anymore.

At least, not alone.

I should take my phone —

 and your number —

call you when it all goes belly up.

I'm Not Her

Close your eyes.

What do you see?

A blushing nothing, reddened by the blaze of sun?
Or me — me, as you last saw me?

Hold on, I say, because I'm not her any longer:
That tumbling, voluptuous mess of sex you remember,
sailor's mouth and devil's tongue —

she's gone.

Her fearless abandon, that heels-over-head bacchanal,
you fell in madly with, she's been swept away...

But lean in. *Listen.* Here, you'll find the glint of my desire,
the mischief in my eyes.

Lean in, I say. *See me.*
Because I am a whisper,
a whisper that can shatter glass.
But I refuse to hurt you anymore.

Morning, Unbroken

I love the still of
morning-nothing-stirring.

The quiet slipping through still,
not a car driving on these city streets,
my feet bare, my inadvertent tip-toe
drawing me closer to cold air.

There is infinite possibility here.

Shifting Shadows

Sun shifting through trees
and slatted wood,
rippling curtains
dance in the wake of my industry.
Movement changes their hue.

This room is alternately
saturated
blown out
through
sun-blind eyes.

The shadows tell their story quietly,
as if nobody is listening.

Each season,
they rehearse the same narrative,
only the supporting roles change.

Today, I'm watching closely,
but the harder I focus on one aspect,
the less I see.

I need to step back,
let my focus soften & expand.

Pulling back,
flooded & dizzy with information,
tipsy with possibility &
winter-cured,
I watch the pieces click together.

If I can just stay removed enough,
if I can just let enough light in,
I can follow the shadow play.

Deliver the Day

This day,
ensconced in crystal paradox,
swept under by stale paradigm.

This day,
it glows before me,
welcome yet hesitant.

Or
I shine dully before it,
hesitating in wonder and trepidation.

Or
I step in
fearless only because I have no choice.

Choice choice choice:
a toxic fallacy.

Choice has a dangerous tendency
to trust without knowing.

Knowing without trust, though,
is a sinking feeling in my centre.

This day,
it shimmers with possibility
and seductive danger.

This day,
I am stripped bare,
reduced to abject solitude.

I face myself and the eyes that return my stare
are hollow and they are tired.

This day,
weighted and daunting,
yet pulsing luminescence.

Deliver the promise of this day.

Morning (I Am)

I am the earth beneath
your feet.

I am the flowers
and I am the trees.

I am eternal.

When I go, I'll slip away,
carried out by the last
rasp — one gasp before
the air goes out forever.

When I'm gone, hold on to
our moments —

Walk with me
in the bright
of the morning.

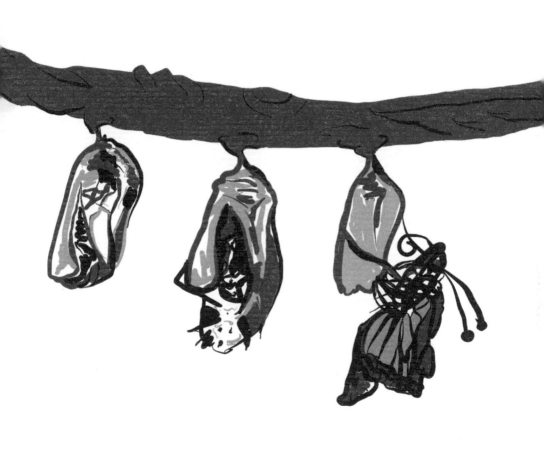

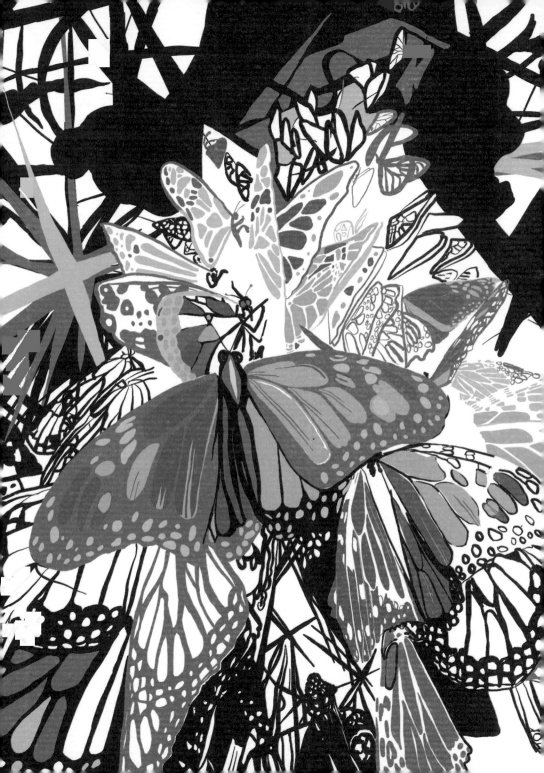

Teva Harrison (1976–2019) was an author and visual artist. She wrote and illustrated the critically acclaimed graphic memoir *In-Between Days*, which was the winner of the Kobo Emerging Writer Prize for Nonfiction, a finalist for the Governor General's Literary Award for Nonfiction and the Joe Shuster Award for Cartoonist or Auteur, and was a *Globe and Mail*, *National Post*, Kobo, and *Quill & Quire* Book of the Year. Forty-five works from *In-Between Days* have been exhibited in a solo show at the Winnipeg Art Gallery. Teva was Principal Illustrator for the National Film Board/National Theatre production of playwright Jordan Tannahill's *Draw Me Close: A Memoir*, a virtual reality theatrical experience blending live theatre and virtual reality technology.

She was a finalist for the Canadian Magazine Award and the National Magazine Award, and her writing appeared in *The Walrus*, *Granta*, *Quill & Quire*, the *Huffington Post*, *Carte Blanche*, *Reader's Digest* (Canada, U.S., and International editions), the *Globe and Mail*, and more. She was a regular commentator on CBC Radio, in the *Toronto Star*, and in the *Globe and Mail*, and she appeared on programs including *Canada AM*, *The Agenda with Steve Paikin*, Space TV's *InnerSpace*, *The Morning Show*, and in *Maclean's*, *Chatelaine*, and Rabble.ca. She was also the illustrator of *The Joyful Living Colouring Book*.